# Photography Badass

Get more clients, make more money

**By, Richard Ramsey**

**Copyright** ©2016 Richard Ramsey

## Dedication

Special thanks to Priscilla Wilson at Priscilla Wilson Photography for her assistance in the testing of different marketing concepts and the feedback she has provided.

## Table of Contents

**Chapter 1 : Create a Focus** : *Figure out what you are and what you represent.*

**Chapter 2 : Social Marketing** : *Understanding social media and how to use it.*

**Chapter 3 : Building the Brand and Website Growth** : *Establish your company, drive traffic to your website.*

**Chapter 4 : Partnerships and Community Awareness** : *Building a business referral network.*

**Chapter 5 : Host an Event / Party** : *Get creative and make bulk sales.*

**Chapter 6 : Customers for Life / Referrals** : *Getting more out of your current customers.*

**Chapter 7 : Outside the Box Marketing that Works** : *Often overlooked marketing practices that actually do work.*

**Chapter 8 : Pricing Strategy and Discounting** : *Learn how to price your product to get more business and generate interest.*

## Introduction

Photography is one of the few artistic fields that can easily be turned into a job that you can be passionate about. Once you have mastered your art and possess the proper skills and abilities the only thing keeping you from being successful as a photographer is your ability to acquire paying customers. Fortunately, marketing isn't the nightmare that many would lead you to believe it is. Marketing is a skill just like photography, but unlike photography it is a skill that can be quickly learned.

The entire purpose of this book is to change the way that you think about marketing. It doesn't have to be boring. It doesn't have to be difficult. It is all about changing your mindset to understand how and why different types of marketing work and how it will ultimately impact your business.

Please keep in mind this book isn't for those that don't already understand photography. It isn't written by a photographer. It is written by someone that truly understands marketing, sales strategy, and customer development. While other books may cover some of these concepts generically, Photography Badass was specifically designed to meet the needs of the professional photographer, regardless of where you are in your career.

The concepts within the book have all been field tested by professional photographers to ensure they are viable, real world options to building your book of business. It was critical that each concept be evaluated in order to develop the best possible practices for the widest range of photography styles.

The book was also written under the assumption that marketing would need to be done on a limited cost basis. As such, each of the concepts discussed within the book are low cost and meant to appeal to everyone from the beginner to the experienced professional. It should not however be assumed that this book will replace hard work. It is meant to be used as a guide to help you market more efficiently. If you aren't willing to put in the work, you aren't going to make it as a photographer regardless of how great you may be.

## **Create a Focus**

One of the biggest hurdles every business must face regardless of what they are selling is defining WHAT they are and WHAT they want to accomplish. This is no different in photography. If you don't understand what you are, you can't expect a customer to. For photographers, this can generally be determined by what you do best or by what you enjoy the most.

Your style may be dramatically different than the style of another photographer, but it is absolutely critical to determine WHAT you are and WHAT you represent. Where most businesses fail is when they attempt to market themselves too broadly. This doesn't mean that you can't make yourself available to do all forms of photography it just means you have to narrow down your scope when it comes to marketing.

Look at the most successful companies and you'll notice their marketing is quite defined. Even major retailers that sell virtually everything imaginable have a focus. You can see this in their Labor Day sales ads that focus around grilling/outdoor activities. While they may offer a wider array of goods, they know that by narrowing the focus they are able to get a better return on their advertising investment. Photography should be no different.

So what are you? Are you a nature photographer, obsessed with catching that perfect action shot? Do you prefer highlighting the human experience? Do you thoroughly enjoy the pain and beauty of childbirth and following children as they age? It is possible that you identify with all of these but until you are ready to define yourself you aren't truly ready to start marketing.

I must stress that defining yourself doesn't mean that you aren't able to provide other services. Having a focus allows you to build a reputation as being the best in a certain area. This allows you to create greater customer loyalty, build brand relationships, and even become a better photographer as you will create a more intimate understanding of that style with greater exposure to it. Think about photography like an athlete. Athletes may be great at sports, but by focusing on a single sport they become better at that sport than their peers. It is all about repetition. Creating a focus is no different. You must define yourself as a wedding photographer, a nature photographer, a newborn photographer, or whatever else you so desire. This is essentially your specialty, much like a doctor would specialize as a dermatologist or cardiologist. You are specializing to set yourself apart from others as an expert in that area.

Another reason to specialize is financial. When you are a specialist you are the authority on that topic. You are better than the generalist. It also means that you are able to charge more for your shoots than someone that is less focused. This is why a dermatologist gets paid more than a generalist when it comes to skin conditions. They may both have the same knowledge, the same access to medications, and ultimately the same outcome, but the specialist is believed to be the expert on the topic. Simply by putting yourself out there as an expert in that area you are stating that you are offering an experience that is beyond what would be received by going to a general photographer. Why would I trust someone

that normally takes pictures of birds with pictures of something as important as my wedding? What makes this wedding photographer think they can take pictures of my baby?

Creating a focus is not only critical to your marketing efforts it is important in overcoming objections during the sales process. It gives you the ability to justify why you charge more than the generalist photographer. You don't want to be the cheapest photographer in town. You want to provide the best "perceived" value in town. Being the expert is the very first step in creating value. Why would you trust a generalist to take your newborn pictures when you can have someone that understands what it takes to position a baby, knows the patience required to wait for that perfect shot, and someone that is able to transform simple props into magical themes? Having a focus allows you to downplay the capabilities of your competition without trashing them directly. If you have a heart problem, you are going to choose a cardiologist over general practice. Make this concept apply to how you look at photography as well.

It is up to you to make the decision obvious for the customer. Of course they would choose you. You are the specialist. **NOTE** : You should NEVER directly attack your competition! This only makes you look bad as a "professional". Professionals sell on their own merits and abilities. In photography, the best way to bash your competition the right way is to compare the quality of their product to yours. This is only advisable if you are confident, you have a better product than they do. If you don't, you should probably consider other benefits to fall back on. Maybe you can offer a 48 hour turnaround. Maybe you do all of the editing yourself and they use a third party in another country. Maybe you offer more pictures for the same price. It is important to know what you offer and be ready to use that information to influence the sale. Again, you are the specialist, you have to believe you are the

obvious choice and the customer will follow. Also assume the sale is yours to lose.

It is recommend that BEFORE you continue on through the rest of the book you determine your focus. This way you can start building the concepts around your focus as you read through the book. Otherwise it is like preparing for the Olympics but not finding out what sport you are competing in until you get there. Whatever you choose realize that this should be something you enjoy. Photography is a career of passion. The more passionate you are about what you are doing the more it will show in your work. Choose something that inspires you and everything else will come naturally.

## Social Marketing

Photography is very unique when compared to most other businesses. It is one of the few businesses where your customers are by default your biggest marketers. This is especially true when your photography is customer focused and truly brings out their passions. This is why it is so incredibly important to really understand WHAT your customer is looking for and ensure that your vision aligns with their own vision or better.

If your customers love what you create they will do all the marketing for you. Just think about the number of times you have seen a friend show professional baby pictures on social media. What about wedding photos? Modeling pictures? Their cars? It is important that you keep your eyes open for these individuals as they are promoters. You want these promoters as your customers as they will drive your business for you.

So how do you leverage the power of promoters? You collect as many as you can! Anytime you notice someone promoting something on social media take note of how many responses they receive. If they don't receive any they may be promoters but lack a viable audience. However, if you see someone that has a considerable response, they are true promoters and you want them as an ally. Thinking back to your focus, you now have to determine if this promoter is someone that you can leverage into promoting

your business. If you do newborn photography, do they have a baby? Are they very involved with their niece/nephew? If you are a nature photographer, are they into birdwatching? If you photograph the human experience, do they volunteer at a food kitchen? Sometimes it requires a little research or knowledge of the person to know if your passions can align. If they don't align, don't force it. Promoters will only promote their passions.

Once you have discovered promoters and have aligned the proper passion, reach out to them. Sometimes a simple conversation about what they love can lead to a sale, but selling shouldn't be your underlying objective here. The objective should be to acquire as many promoters as possible especially when you are first starting your business. This can be done in a number of ways:

**Pay to Play Promoter**

This type of promoter is someone that hired you to take photographs. They typically trusted in you enough to spend money to capture something important to them. (ie: their passions). To take advantage of this paying promoter it is simply a matter of delivering their pictures and hoping that they share those pictures online.

The better option would be to ask for the customer's permission to use the photographs for marketing purposes. Doing so allows you to not only share their pictures showcasing your abilities but it also allows you to tag the customer on social media. By taking the promoting out of the hands of the customer, you are able to promote directly to their social network and get paid for it in the process.

**Passion Promoter**

In the beginning of the chapter we discussed finding promoters that have identifiable passions. These are the best types of promoters to have. Not only do they enjoy sharing their passions, they have a strong responsive social network and tend to be very loyal customers.

Passion promoters can be sold, but if a sale is not immediately obvious sometimes you can still use a passion promoter to help promote your business. One option would be to use their passion for marketing purposes. Assume your passion promoter is obsessed with dogs and you just happen to be a pet photographer. In this scenario, you could ask the passion promoter if they would allow you to photograph their dogs for an upcoming Christmas shoot you want to promote.

The great thing about this approach is that you are not only promoting your shoot, you are now creating a passion promoter as an ally. If they appreciate what you did they will not only promote your photographs of their dogs but are more likely to consider becoming a paying customer in the future.

If you are going to use this approach it is VERY important to remember to NEVER offer the same person more than one free session. The goal is to turn everyone into a paying customer. Once you are already marketing to their circle they have no more added promotional value that you already receive and a free session would serve no additional benefit. If you want them to promote again you would simply tag their pet in a new unseen photograph from the same session.

Remember that passion promoters should never be customers that are currently paying. The goal isn't to give away free photography sessions. The goal is to market to a customer base you aren't

currently marketing to. If you give away a session to customers that currently pay you are marketing to the same people you were previously marketing to AND you just lost a paying customer. This is why you also shouldn't give away a session to those closely linked to others you are already marketing to.

**Contest or foreign Promoter**

In order to market to a completely new demographic you may want to consider a contest or foreign promoter. These promoters are typically people you have never made previous contact with or may have had very limited interaction with. While their ability or willingness to promote is completely unknown they should be able to reach a customer base that you aren't currently reaching. This is especially true if they were discovered outside of your normal circles.

Contest promoters can be acquired through drawings at shows or online offers where you are "looking for models". The goal of any contest is of course to draw attention to your brand which is why every contest should be heavily branded so even the losers know who you are. The winner of course would receive a free photography session. As a requirement of this session, you should ensure that they have social media and are willing to allow you to use the photographs for marketing purposes.

For the losers you should still offer them the same session that the winner received but at a reduced premium. You can still use them for marketing purposes but now you may also make a little money in the process. Again, the ultimate goal should be to work towards the creation of paying customers.

Regardless of what type of promoter you are using you have to remember that the end goal is to create paying customers. In order to accomplish this it cannot appear as if you are constantly giving away business. While this can be somewhat tricky in the beginning while you are attempting to build your portfolio there are steps you can take to ensure that you aren't cheapening your brand with "free". The best way to do this is by avoiding the use of the word "free". You are looking for a model to promote your holiday photographs in exchange for photographs. While free is inferred it isn't directly stated. The word "free" devalues your product and as a specialist in your area you definitely do not want to devalue your product. Looking for models can also make your product sound more glamorous. You aren't taking pictures, you are taking photographs. Wording is important, especially when building value.

It is also important to remember that once you create a promoter you have a promoter until they tell you stop using them as a promoter. During a session you should always ensure that you take more pictures than you need to fulfill an order. These additional photos can then be used as teasers to encourage a promoter to promote some more. These can be used to tag the customer months or even a year down the road as a "flashback" or "throwback" to a great photo shoot. Again, once they see these pictures they will inevitably promote to their friends. The hope is that their friends will ask who took the pictures resulting in more business.

The use of promoters can be hugely beneficial to any business but in the case of photography it can also become VERY viral. By simply coming up with creative concepts that draw attention you can turn a photograph into a viral sensation that is shared around the world. This is why it pays off to think outside of the box and come up with concepts that are unique. The more marketing you allow others to do for you the greater exposure your

business will have and the less money you'll have to spend to generate that exposure.

There are a few things that should be kept in mind while using this strategy. It is imperative that you focus on creating paying customers. If you want to convert non-paying customers into paying customers you should NEVER photograph the same person twice in exchange for marketing. You already have access to their social network. Going after the same network again only means you are working for free. This customer has a greater potential to become a paying customer now that they know what you bring to the table. Keeping them from transitioning from free to paying only hurts your business.

You also need to remember that when it comes to social marketing consistency is important. If you allow your name to disappear from the spotlight it is very easy for the customer and their friends to forget about you when they need a photographer. Often times businesses are so afraid that they are going to annoy their customers that they forget to market altogether. You absolutely have to be consistent. The rule of thumb for marketing is 3-4 touches. This means that it generally takes at least 3-4 direct contacts before a potential customer will engage you. This means it could take 3-4 phone calls, emails, direct mail, or some form of direct communication that is aimed specifically at that customer. So if you are passively marketing to them, you must realize that it will probably take more than 3-4 touches. Again, consistency is important. This doesn't mean making five posts a day, but it does mean something needs to be happening at a minimum once a week. If you have no new clients that week, find a model. If you don't want to find a model, repost some new pictures from an old shoot. Just make sure you are keeping it fresh.

## Building the Brand and Website Growth

Your brand itself is sometimes just as important as the marketing you do. Sometimes the brand can even become so valuable that it drives demand. This is why it is very important how you name your company, how you market the company, and how you act while representing your company. Tarnish your brand and it becomes very difficult to repair the damage. Develop and take care of the brand and it can pay out major dividends.

Brand creation isn't usually an area that photographers fall flat. This is mostly because the brand often times is their name. So they are essentially the brand. Where the issues normally come into play is the actual development of the brand. The brand itself has to be looked at as something much bigger than just a name. It should be looked after much like you would a newborn. You have to take special care to nurture it and find ways to help it grow.

So the big question becomes, how does one develop the brand? The simple answer, recognition! This can be accomplished in a multitude of ways, but for the purpose of this book I will be focusing exclusively on those methods associated directly with marketing.

**Blogging**

A major part of creating your brand and ultimately justifying the rate your customer pays is the perception of value. A way to build that perception of value is to further develop your professional image. One way to do that is through blogging.

Blogging could follow two different formats. You could either blog about photography from a teaching / industry perspective OR you could blog about your shoots, what it entailed, what you were trying to accomplish, and what ultimately happened. As long as the blog is tied back to your website it doesn't ultimately matter what slant you take as long as you do something.

The simple act of writing about a topic shows a level of comfort in your knowledge in that topic. This can help to reassure potential customers that you aren't just someone with a camera that takes pictures, but someone that is trained and knowledgeable in the field of photography. From a marketing perspective the simple act of blogging about photography creates a lot of fancy little keywords that help search engines index your site. In other words, blogging can help you show up better in search results.

Another great potential impact of blogging is that often times it will lead to sharing, linking, etc. It never hurts to have a few other websites pointing your way. Not only can this benefit you from direct traffic, but this can show search engines that your site probably deserves a higher ranking in listings.

If you are blogging about your sessions it can even show your human side. Customers want to feel like they are more than just money. By blogging about a session, you are showing that you are human and that you truly are passionate about what you do. If you

have a great personality, this alone could help you book more sessions. People want to do business with people that they like. It is also very difficult for a customer to say "no" to someone that they have built rapport with. By simply being a likeable person you are going to improve the number of leads that turn into sales.

Blogging can even be taken a step further. If you are blogging about parenting you should consider emailing those customers of yours that are interested in that type of information. If you blogging about pets you should do the same for those customers. The idea is to make your blog entries a regular topic of discussion in your email campaigns. The goal of the blog should be to bring out your human side. If you are simply stating facts and not bringing your personality into your blog you will make it difficult to others to relate to you. Make it fun and upbeat. Always avoid the negatives, unless you can make the negatives humorous. Give your customers a reason to follow you beyond photography alone.

**Create Guides / How To**

As a photographer you tend to become an expert in what you shoot. If you are a pet photographer you will quickly learn about the different breeds. If you do wedding photography you learn about different venues, DJs, catering, and more. If you a newborn photography you learn about the psychology of children. This information isn't just meant to make your job easier as a photographer, it is information that you should share with the world to make their lives easier as well.

How do you share this information? Create online guides! One of the most common searches online is for information on how to do this or how to do that. Creating guides that showcase your knowledge of not just what you do, but all things associated with it helps to build your brand and shows customers that you are truly a

professional in your field. Much like blogging, creating guides will also help build website traffic and hopefully result in more sites linking to your own.

**Contributing**

Another great way to get your name out is to contribute to other websites. This could mean simply contributing your photographs to different contests, posting to photography group pages, etc. It also can mean writing photography related articles that will help to show your knowledge of photography. Again, these are great ways to get your name out there. They can also help to provide additional traffic to your website especially if you ask for them to provide links back to your site.

While contributing can be time consuming and the benefits are often times more long term, it is important to consider a variety of different marketing strategies. Contributions with links back to your site can not only create click traffic from one trusted source to your site, it can also help boost how search engines index your site.

Even contributing to different message boards/forums if done properly can have an impact. For a nature photographer, joining several message boards about nature may be beneficial. This doesn't mean just nature photography forums but any forum that discusses nature. By simply posting your website in your signature each post you make can potentially earn you additional visibility. This is especially true if you post to popular threads that are indexed in search engines.

It is a good idea to reach out to websites that match your focus and offer them photographs that may help to enhance their website. If you want to work with a parenting blog it may be a good idea to see if you can trade exposure for photographs that match whatever topic they are writing about. In other words you would give them

the stock photography that they need in order to further illustrate their topics. These types of trades can be mutually beneficial as bloggers tend to have a very dedicated following. Tapping into this dedicated base is a great way to generate new customers. Before creating these partnerships it may be a good idea to understand their demographic. If the blogger is a California blogger and you live in Florida it is possible that you will get only a limited benefit from the partnership. However, having additional links from a recognized source can help boost your ranking in search engines.

**Tagging / Imprinting**

Ever notice that same van driving around your neighborhood advertising that popular diet craze? How else did you hear about it? It is possible that the only way you would have known about it is through that vinyl sticker on the back of that van. This is called tagging/imprinting. The more often you see this van, the more likely it is you are going to remember it. The same is true with any type of marketing. Why else would advertisers show the same advertisements numerous times during the same television show? They are trying to imprint it into your brain hopefully deep enough that it becomes your first thought when you need whatever it is they are selling.

A great example of how effective imprinting can be is to think about those lawn signs that are all over the roads. I may have absolutely no need for guitar lessons, but the same sign for guitar lessons is all over the place in my neighborhood and I drive by it several times a day. The moment someone asks me if I know anyone that does guitar lessons I will immediately think back to Dan the Guitar Man. I have done no business with Dan, I have no connection to Dan, but his marketing has effectively been imprinted on me.

Does this mean you need to post signs all over town? Not exactly, but it does mean that you have to find a way to get your name out not just one time, but frequently. Frequency is what imprints a brand into your mind. The best part is that it also builds your brand at the same time. The more often a customer sees your company name the more legitimacy it creates. It is assumed that only a reputable, successful business could be in so many places. Again, perception plays a major role in marketing. Sometimes it is a matter of appearing bigger than you really are.

An easy way to imprint on your potential customers is by simply having your family wear shirts with your company name on them. This doesn't mean wearing them one time to some event. This means wearing them frequently, all over town. In order to imprint a customer needs to see the same thing over and over again. It is also important that the message, logos, and design are similar. This is because imprinting can happen either because a consumer remembers a logo, maybe the slogan, or possibly just the style of the marketing. By keeping a standard format on all forms of advertising there is a greater opportunity to imprint your brand on others.

If a consumer sees your shirt when they go to the grocery store, sees the vinyl sticker on your car, and now sees you at a craft show, they are much more likely to take your business seriously. These small things alone do not legitimize your business, but when the name appears in different formats with frequency over a period of time, the name will imprint in a customer's mind until eventually it is their first thought when they think of photography.

**Five Foot Rule**

Imprinting can also come from passing out your business cards. One of the best forms of marketing is something referred to as the five

foot rule. It means nothing more than passing out your business card to anyone that gets within five feet of you. Unfortunately, most businesses are too afraid of rejection to follow through on the five foot rule. They are so afraid of being rejected that they would rather fail instead of promoting their business. Who cares if you are told "no" or "go away" 99 times in a row. What about that 100th time that works? What if that person is also a promoter? Even the worst hitter will accidentally hit a ball if given enough chances.

I realize many people would consider this somewhat extreme, but that's why it works. If every business owner did this it would be ignored. The problem is that by not doing these simple things you are saying that you are too embarrassed by your company to promote it. Why would a customer want to do business with someone that is embarrassed by their own brand? When you refuse to do the simple things to promote your brand you are saying that you don't believe in your brand. You are more afraid of looking dumb than being successful.

In marketing, everything is about numbers. The more people you reach the more opportunities you will have. The five foot rule can be incredibly effective but it requires a lot of effort. You have to make the decision that you would rather be successful than scared. If you aren't generating new contacts every single day you leave your house, you are failing your business.

When it comes to the five foot rule, the best approach is to set a goal. This goal should be something that is realistic like 20 cards a day. Part of this goal also needs to include accountability. You have to make yourself accountable for hitting your goals. If you say that you are going to hand out 20 cards a day then you have to make certain you keep working until you hit your goal even on the busiest of days. The idea is that by doing it regularly you are going to keep the funnel of potential customers full. When you stop marketing,

that's when your leads fall off and you experience a lull in business. By staying consistent in your marketing efforts your business will also stay consistent.

Building your brand isn't always going to be easy. It is going to require work and dedication. Writing a blog one time isn't hard. Writing a blog on a weekly basis definitely can be. It is important to create habits and consistency if you want to be successful. You aren't always going to see immediate results. Unfortunately, this is why so many people give up on their marketing efforts. Marketing is about staying consistent and doing regular activities to get your name out. Building your business is no different than working out. Sure you may see some instant success here and there, but the only way to see long term results is through consistency. You have to stay dedicated to your business if you want to be successful.

The easiest way to stay consistent is to create a schedule. Decide which day of the week you are going to blog. Pick a day each week to contribute to other sites. Pick a day where you are going to talk to as many people as possible. These activities aren't ones that you do once a month and that's enough. You have to constantly work these programs and eventually you will see the results. Ignoring regular promotional activities is the same as ignoring your business and giving up on your own success.

## Partnerships and Community Awareness

Getting involved in the community not only shows that your business is interested in supporting those around you, but it is also a great way to make your brand more visible. This is a huge area of opportunity that is often overlooked by businesses. These partnerships can often times become major lead sources and ultimately create regular income for a business if they are properly maintained.

It is also important to go into partnerships/awareness programs with a plan. Those without a plan are simply volunteering. Those with a plan can not only volunteer, but get some benefit for their business as well.

### Charity / Volunteerism

One of the best ways to enhance your brand is to get involved in charities. While you can do this in a number of different ways, the most visible is by directly offering your services to the charity. Photographers serve an important purpose in chronicling an event. This is especially important when it comes to annual events. Charities generally want to show what was done in the past in order

to promote for the future. Your business should be involved in this process!

The best way to involve yourself in a charity event is by creating an offer package detailing what you are willing to offer and what you want in exchange. Ideally you would chronicle the event itself and provide these general pictures directly to the charity for marketing purposes. In exchange, you could simply ask for a marketing table at their event. You could even take pictures of individuals and families and give out cards so they can access the pictures on your website after the event. Not only would you be marketing, but you would be driving traffic to your website which will hopefully drive further business.

If the charity will allow you to do so you should always wear your business branded shirts to their events. By simply having your brand on your shirt you are going to create additional awareness of the brand and hopefully you will continue your efforts to imprint your brand which was discussed in a previous chapter. If the charity will not allow you to wear your company shirt and wants you to wear the shirt representing the charity make certain that you are getting a table or some other marketing benefit. Volunteering is a great thing to do, but if you can volunteer AND get a marketing bump you should definitely take advantage of it. If you never ask for these things it is unlikely they will simply offer them to you. You have to be the aggressive one and ensure you look out for yourself and your business, regardless of the cause.

Even if you aren't planning to participate in an event directly try offering your services as part of a drawing. Just having your name associated with the charity can be good for branding and is something that you can blog or post about on your site and social media.

## Church / School / Organization

Another play off of the previously mentioned charity concept would be to work directly with churches, schools, and other organizations. Many of these organizations could benefit from having a photographer on hand to take pictures of their staff, members, etc. The idea here is that you would exchange your services in order to be part of the marketing to their members. This could mean a mention in the school newsletter. It could mean having permanent advertising on their website. The type of partnership that you work out depends entirely upon the type of organization and what they have to offer.

A good example of how a partnership can be beneficial is a pet photographer working with a local animal shelter. You would provide photography services in exchange for mention in social media posts, links from their website, or even inclusion in a welcome letter when someone adopts a pet. They will have the benefit of higher quality photos that will hopefully draw in a greater number of adopters. You will get the brand recognition for supporting a great cause and hopefully additional business because of it.

The best part about working with these groups is that you can build your brand while helping a good cause in the process. These types of partnerships are ones you should promote on your own website and social media pages as well. Letting your customers know that you are involved in the community can have a very positive impact on your brand. Many consumers will do business with a company just because of what they support. Just remember that this can work in reverse as well. If you support a cause that is unpopular it can create a backlash. Always research the companies you partner with before creating those partnerships.

## Wedding Planners / Dog Walkers / Service Providers

If you want to work more weddings, why not work directly with wedding planners. The same is true with other services. Find those that do jobs that can coincide directly with your focus. Once you find those people find a way to work with them. You want their referrals!

In the case of wedding planners, this is a super obvious partnership. How do you approach them? Offer to do a complimentary photoshoot of their family. This is especially useful when you have a wedding planner that has small children. If they love your work they will promote you not just as a business partner, but as someone that has experienced your ability first hand. A customer is going to trust their wedding planner to provide high quality referrals. This trust can have a major impact on their willingness to use you for their services.

You could also work with a doula to provide childbirth photography services by photographing their own childbirth first. Doulas have a very personal relationship with their customer base. Having them refer you for childbirth photography can hold a lot of weight for this reason.

Dog Walker? Photograph their pets. Just like someone with a child, true pet lovers truly believe that their pets are part of their family. Often these dog walkers were carefully selected and are highly regarded. Take advantage of this relationship. Keep in mind that someone using a dog walker on a regular basis is someone that has disposable income and a true love for their pet. An average pet owner will make their dog wait in a crate until they get home, but someone choosing a dog walker puts their pet in higher regard. This is the type of consumer that is willing to consider pet photography.

**Boutiques / Doctors Offices / Retailers**

Just because a business is for profit, doesn't mean it isn't a great opportunity for a partnership. Many times these businesses are going to be more inclined to promote your business if they have a vested interest in your partnership succeeding. The key is to understand the businesses that you are working with so that you can come up with a partnership strategy that is mutually beneficial.

If you are a pet photographer, a good idea would be to approach veterinarian offices. You could do a pet model search in order to provide pictures for their office. For the veterinarian this shows that they appreciate their customers and their pets. It also provides them with high quality art for their walls. For the photographer it could mean regular access to pet owners. Part of the agreement could include keeping literature in their office in exchange for regularly updating the pictures on their walls.

If you do newborn photography working directly with a children's boutique could be extremely beneficial. You could market their products to your customers or use only their items in your newborn photographs. You could also do scheduled newborn shoots directly at the boutique and provide the boutique with a share of the cost or simply let them benefit from the additional traffic.

If you do sports photography an obvious choice would be to work with sports retailers, leagues, and local teams. Taking complimentary team photos in exchange for allowing you to market

individual photos or action shots to players/parents may be a great way to get a foot in the door.

If you do children's photography or love doing birthday parties you should consider creating packages with an entertainer, face painter, bounce house provider, and anything else you can imagine. Each provider would promote the package and the other possible services. Working together you will get a far greater number of opportunities than you would individually.

Also consider stables, tour operators, wedding venues, animal breeders, property managers, realtors, and so much more. Sometimes the craziest ideas may yield the best results. It is important to think outside of the box a bit to come up with the best partnerships.

Building partnerships is more about building reliable consistent business than anything else. It is a source of customers that should only grow as your business grows. It takes time in the beginning to build these relationships but over time they will provide your business with a steady source of referrals. It is important to stay in contact with these businesses to keep the partnerships you have already established working for you.

Imprinting was discussed earlier and also applies to your partnerships. The more often they are reminded you exist, the more likely they are to refer you. It also helps if these businesses like you as a person and see you as a friend. When you approach partnerships they need to be looked at as long term investments or friendships. They are considerably more likely to refer your business if they see you as a friend.

It is also important to recognize your best partnerships. This is traditionally done with gift cards, food baskets, or even candy. These gestures show that you appreciate what they have done to help promote your business. By ignoring a partners contributions you could risk losing that partner altogether.

**Family Reunions / Parties**

Large family reunions and parties can also be a great source of leads. By simply offering to do a complimentary family picture you can get into the reunion. Once you are in the door, you could offer discounted pictures of individuals and their immediate family. When someone is caught up in the moment of a reunion they are more likely to make an emotional purchase.

If you are going to do this type of photography make certain you get permission to market to the family members prior to agreeing to do a complimentary photograph of the whole family. It would also be a good idea to check to see if there is a family newsletter, blog, or other information being used to market the event. If there is, it would make sense to see if you can market your services ahead of time for the individual families. Doing this will make your on-site marketing a lot easier and expected.

## **Host an Event / Party**

Events can be a lot of work, but they can also be extremely profitable if done correctly. These events can be super intimate with just a small group or large events with numerous vendors. The idea is to create events that will ultimately allow you to showcase your work and network with other business owners.

There are many companies that exist almost exclusively because they are successful in event marketing. While these companies typically focus on small events in intimate settings, events can also be much larger scale depending upon what you would ultimately like to accomplish.

**Parties / Intimate Settings**

Parties can be a fun way to connect a little more directly with your customers. These can be of any size and theme you choose. For example, you could do glamor parties that you market to groups of women. To do this you could work with a hairdresser, makeup artist, nail technician, and provide a group of friends the opportunity to get their hair, makeup, and nails done along with a professional photography package. Maybe you could do this around Valentine's Day or Christmas as a way for women to give their

spouses a very special gift. You could offer either traditional pictures or something a little more risqué. This could also be sold as a "night out" package where women are done up to celebrate a birthday, graduation, or even the end of a divorce.

Mini sessions would also fall under this category. Rather than your standard rate, you could offer a much lower cost with a limited package as long as your customer booked for a specific theme on a specific mini session date. By doing numerous shoots on a single day using a single theme, your costs are reduced and as such you are able to pass the savings on to the customer. With the mini session it is all about getting as many shoots done in a single day as possible. If you are still scheduling individual shoots it defeats the purpose of doing a mini session. It is all about bulk when it comes to the mini session.

Other ideas to illustrate the flexibility of this concept:

- Puppy Parties : Host a party with dogs and their owners. Provide photography at the party and allow the customers to buy prints from your website. You could also provide mini sessions at the party.
- Couples/Singles events : Host small events inviting couples for dinner, wine tastings, and a photography mini session. Create packages with local restaurants or venues.
- Theme Parties : I'm sure everyone has been to an 80's party, superhero party, or some other themed party.
- Paparazzi Party – You pretend you are following around a group of celebrities. The pictures could be themed to look like magazine covers. This would be great for kids on a birthday party.

People love to have pictures of themselves out having fun. This has never been more true than it is now with a world so involved in

social media. Having professional pictures that show that they don't just sit at the house and binge watch Netflix are in demand. It is your job to realize this and take advantage of it. To do this, you must remind potential customers that they can use it on social media. Remind them that they want the world to know that they were at such a fun event.

While many people will not come out and directly say it they want to look good on social media. Just think of all the people in your life that are in terrible relationships, have horrible kids, or are struggling financially. As soon as you go onto their social media pages they look like they are doing great financially, they are completely in love, and have the sweetest little angel children. As a photographer it is your job to help them create their fantasy. Sometimes this means you have to remind them about this fantasy.

**Large Events**

By creating larger events you are able to select the venue, select the theme, and choose what companies are allowed to attend. You also have direct control over where your own table is going to be placed and how your own business is going to be marketed to consumers. These events are great because it allows for multiple businesses to share in the costs of marketing. You come up with the theme, market to other businesses, and charge them for each table. That money is then used to market the event.

If done properly an event should not only pay for all of its own expenses, but provide your own business with a free marketing

opportunity, and hopefully some additional income in the process. These events are also a great way to reward your partnerships as you have control over what their cost would be to participate in the event. If you have great partners, you should consider offering them a complimentary booth.

As you can see parties/events can be as creative as you would like, but unlike other concepts this one requires a lot more planning and organization. Knowing what you are hoping to accomplish and understanding what it will take to make the event successful is important. A poorly planned event could tarnish your brand so it is a good idea to make certain you have the ability to properly execute any type of party/event prior to launching the concept.

It is also advisable to consider going to several different types of parties and events to get a better understanding as to how they work prior to planning one yourself. This will also help you to recognize potential problems before they occur.

## Customers for Life / Referrals

It is likely that at some point in your life you have heard that it is easier to keep a customer than it is to find a new one. While this concept is most commonly used in banking, insurance, and other similar industries it can apply to photography as well. Too often service businesses will look at a job with a "one and done" mentality. The assumption is that once you provide the service you are now done with that customer and need to move onto the next.

The reality is that most consumers would prefer to do business with a company that they trust. Part of this trust is familiarity. This is why consumers will choose to shop at the same grocery store every week, buy the same brand of bread, or read the same newspaper. It isn't always just convenience that drives these behaviors. Trust and familiarity with a brand can also alter decision making.

Once you have photographed a customer this should be seen as the start of the relationship, not the end. This is now a consumer that you know is interested in the types of services that you offer and is willing to pay for them. This consumer also happens to be aware of your services, knows the quality of your product, and is now familiar with you. Assuming the customer had a positive experience they should be more likely to use you than your competition in the future.

Consider this, you are going out to eat for a special event and you have two options; you can select the restaurant you have been to and really enjoyed OR you can take a chance on a restaurant you know nothing about. Which will you choose? Most consumers will not risk taking a chance on their special event with a company they are not familiar with as long as they have an option they are familiar with.

The biggest issue with familiarity is the customer has to remember you exist for it to continue to be effective. This means adding EVERY customer on social media, collecting email addresses and adding EVERY customer to your mailing list, and having a physical address for EVERY customer so that you can send direct mail, birthday cards, holiday cards, etc. You cannot remind your customer you exist if you don't have a means of contacting them. Collecting this information only matters if you actually use it to market to them. It can't just be a good idea, it has to be a good idea that you put into use.

Previously I mentioned how important it is to maintain an active social marketing profile. Just the act of posting on your social media pages on a regular basis can make a major difference on whether or not a customer remembers you. Sending out regular emails can help as well. Customers should know about any promotions that you are offering, any themed photo shoots, and even if you posted a blog that may relate to them. Email marketing is VERY effective if done properly. It not only reminds your customers that you exist, it is a "call to action' to remind them that it is time for their Christmas pictures, birthday pictures, etc. It is also a good idea to know what events are important to your customer so that you can send them reminders about when you are doing themes relating to these events. For example, if they love Valentine's Day photos, maybe you should be reminding them about your Valentine's Day mini shoot or your themed boudoir

parties. You cannot assume the customer is going to come to you during these events as they may forget about it until it is too late to do it. When that happens, you lost a customer that could have purchased a package had you simply kept up with your regular email marketing.

**Email Marketing**

To be effective, email marketing should be done on a regular basis at least once a month, but preferably every 1-2 weeks. These emails should always contain some type of useful information. If you have nothing to share, think of something. If nothing is happening in your business worth sharing at least once a month, you aren't working hard enough.

What should be included? Your email marketing should include "What is happening/coming up", "Promotions", "Blog posts", and of course you should be highlighting your work. If you just did an amazing shoot make it part of your newsletter. If you want more business you have to inspire the passions of your customer base. For a pet lover that may be a goofy pet photo shoot. For a parent that maybe a newborn dressed as a cowboy.

Do not put out an email just to put one out. There is nothing more annoying than getting a marketing email that tells the customer nothing. Make it count! You are sending an email to the people that are most likely to buy from you, why wouldn't you spend time on it?

**Social Media**

Social media is a major part of marketing. We have already talked about using social media in a separate chapter so I will keep this somewhat short.

You should be posting to social media AT LEAST once a week and responding to comments at least once a day. Make certain your posts are meaningful. Sending out meaningless posts only makes it easier to ignore the good posts in the future. If you have nothing to say bring back an unseen photo from an old photoshoot. If you don't have any unseen photos, get some. Make certain you are tagging your clients in these photos. This is yet another opportunity to remind them who you are and of course reach their own friends/family one more time.

Pinterest should also be considered as an opportunity for photographers. By adding every shoot, every blog, and every guide to Pinterest you are adding more links back to your website hopefully resulting in more traffic. This also helps improve your chances of having one of your more interesting photo shoots going viral. Just another reason why you should consider creating photography shoots that are a little less than traditional from time to time. This doesn't mean it has to be risqué, it just means that you can be rewarded for your creativity if you take the time to get it in the spotlight.

Facebook has several different online bartering, networking, and trade groups that you can join. These groups are often made up of thousands of members from a specific geographic area. By joining these groups you can target this customer base and post promotions directly to those in your local area.

There is also an app called Nextdoor. This app is a social network for neighbors. You have to prove that you live in a certain neighborhood to join which means that the people using it actually live nearby. The great thing about Nextdoor is that many of your neighbors will post looking for recommendations on different services, including photography. You can also make your services

available. It is a great way to network with those in your neighborhood.

**Direct Mail / Post Cards**

Direct mail isn't used nearly as much as it once was, but can still be an effective form of marketing. The biggest reason behind the decline of direct mail is the cost compared to no or low cost options available thanks to the internet. Direct mail still does serve a purpose, especially when it comes to major announcements.

While many companies have gone away from using direct mail for birthday wishes and have instead opted for email instead, this change may give greater reason for using direct mail. With so many companies sending out emails on a customer's birthday your message often times will get lost in the pile. By using direct mail you may be sending the same message but the customer is more likely to notice it as fewer companies are using the same delivery method. Direct mail also shows that they are more important than a mouse click.

If you are going to use direct mail, make it count. Far too often companies will send out direct mail with some basic information about the company and that's about it. When using direct mail there should always be a "call to action". This is simply something that makes the customer respond. This could be a contest, a promotion, or maybe even limited availability. A call to action takes the customer decision making process from inactive to active and forces them to make a decision about the potential purchase right now. By forcing them to make a decision now you are reducing the chance that they will forget about your offer altogether. While the customer may have the best of intentions to use your service, procrastination is a normal human response. By taking procrastination out of the process you are ensuring better results.

Also, if you are going to send direct mail it is normally a good idea to follow up that marketing with a phone call. Just a simple, "Just calling to see if you received your special offer" or " Did you notice that we are offering a free gift with purchase?". I mentioned earlier that a customer typically needs 3-4 touches before they will make a decision. By sending your regular emails/social media that is one touch, the direct mail is the second, and the third would be the phone call. Continual contact with your customers reminds them of your presence and prevents a competitor from swooping in.

When using direct mail you should also consider the low rate of return. Generally a 1-3% response rate is considered successful. If you are sending out 100 direct mail pieces, 1 response would be considered a decent return. This doesn't mean they are buying your service, this just means they responded. Of those that respond, you should typically sell 1 in 4. If you are a good salesperson, 1 in 3. With that math you would need to send out at least 400 pieces of direct mail to get a sale. The reason why this is important is because you have to know your cost vs reward. If you are spending more for the marketing than you are making back, you may want to consider using a different method of marketing.

Knowing your customers and showing that you appreciate their business goes a long way towards retaining their business long term. This loyalty will also impact their willingness to refer more business to you. By keeping yourself imprinted in their mind you ensure that they are more likely to remember your name when someone mentions they are looking for a photographer. It is also important that you take the time with EVERY customer to ask for referrals, even offering a referral special if they do refer someone that purchases.

The most important thing to remember about referrals is that you aren't going to get referrals if you don't ask for them. Since referral business converts at a much better rate than other leads, it may be a good idea to do regular referral promotions. One idea would be if a customer brings a friend that also books a session they both get 25% off their session.

## Outside of the Box Marketing that works

Customers can come from anywhere. If you remember that every conversation is a potential opportunity you can start to generate business in ways that you would have never considered. Previously I had mentioned the "five foot rule". This is an example of taking advantage of every opportunity. If you were to simply make it known that you do photography to everyone within 5 feet of you eventually someone is going to take interest and book a session. You can take this rule a lot further if you think outside the box.

**Marking your territory**

The 5 foot rule doesn't need to apply to JUST conversations, it can apply to spaces as well. By spaces, I am referring to any visible place that you can stash your business card. This means every fishbowl drawing, every waiting room table, and even on the bathroom stall. The more places you put your business card, the greater the opportunity to be seen and hopefully contacted.

Some location ideas that are often overlooked include : Inside of menus at restaurants, under the glass on top of tables, above urinals, in the pockets of clothing, inside taxis, on buses, or anywhere with high visibility or forced interaction with the card.

This method of marketing tends to require a great deal of patience but with consistency it can pay off over time. I wouldn't however recommend making it a point to go around to businesses all day just for the purpose of placing your cards on tables. This method of marketing is generally meant to be part of a set of habits that are meant to help you promote your business in some form every single day. This is the same as wearing your company shirt when you are out in public. These habits can ensure that you are doing something TODAY to earn business.

**Uber / Lyft**

Ride sharing is becoming an incredibly popular mode of transportation, especially in urban areas. It is also an excellent means of generating business. If you are unfamiliar with the concept, basically Uber/Lyft are apps that allow you to request a ride from an individual that has made themselves available to drive around other people for a fee. The drivers are vetted by the company itself and are rated for quality.

There are two different approaches that you can take to use ride sharing for marketing. You can either do it as a passenger or as a driver. If you are doing it as a passenger it is as simple as talking to the driver and letting them know what you do. You can also leave your cards behind in their car and hope that other passengers pick them up.

The better option is to use ride sharing as a driver to promote your business. The best part is that you will actually get paid to promote yourself while driving. To promote your business while driving you do have to be somewhat careful on your approach. Leaving your business cards in the car is the obvious choice, but you can also bring it up in conversation. This is generally how you are going to get the best leads. Since those riding with you are a captive

audience you have the opportunity to get to know them and their needs and have time to sell your product at the same time. Just remember that they are paying for you to drive them around, not market to them so you have to be careful and casual about your approach.

If someone sounds extremely interested, have them write their number and/or email address on the back of a business card so you can contact them later. By simply handing your card out you are taking a chance that they may lose it or forget about it by the time they are done for the night.

It is also a good idea to give out your card if the customer asks whether or not they will be able to find another ride later when they are ready to come home or even if they mention they would love to have you as their driver again. These statements show they are starting to trust you and also means you have the rapport necessary to hopefully earn their photography business as well.

## **Pricing Strategy and Discounting**

Pricing wasn't originally going to be part of this book, but after doing considerable research I discovered that pricing is a huge opportunity area for many photographers. It is also an important aspect of any marketing plan.

The biggest issue that I have noticed is that there is a considerable difference in pricing strategy from one photographer to the next. A lot of this is due to level of experience, but much of it is fear based. Far too often we look at price and worry about whether or not it is too high for a consumer to accept. The reality is that if you believe in your product you have to charge what you are worth. In a field such a photography this should be different from one photographer to the next based on ability. It shouldn't however be as significant as it is.

The problem is that some photographers are charging $50 for a sitting while others are charging upwards of $500 or more. This goes well beyond the ability gap. This is just stupid business. If you are one of the photographers charging $50, you are the problem. You are destroying your industry. You are cheapening your brand. You need to change.

If your quality isn't good enough to charge more than these minimal prices you should not be charging for photography at all

until your quality is good enough to warrant it. You should be training with other photographers to learn the skills necessary to be an elite photographer. Simply owning a camera does not make you a photographer. You must know how to use it. You must know how to pose. You must know how to edit.

As a professional, you are liable for any damages you may cause based on your misrepresentation. If you represent yourself to be a professional photographer and photograph a wedding poorly, you will get sued. Maybe not the first time, maybe not the second time, but eventually it will happen. Do not risk your future by attempting to produce a product that you do not possess the ability to produce. This only hurts the professionals that have spent years working on their craft and learning how to do it properly. Beyond that, ruining the memories for events as important as a birth or a wedding for money is terrible. Your customer cannot redo their child's birth or their wedding with a real photographer. Get the skills you need first before you charge for photography.

For those of you that are charging low prices and have the ability, you are destroying your industry and tarnishing your brand. You may think that you are getting more business by having better prices than your competition, but all you are really doing is working harder and hurting your brand in the process.

The customers that aren't willing to pay more for photography are the customers you do not want to have in the first place. Customers that are so focused on price are customers that don't have the disposable income necessary to be long term customers. Those customers that do have the disposable income are less inclined to do business when they feel like a company is too cheap. Often times they will feel as if you are cutting costs, have less experience, are less reliable, or simply because you lack everything they are looking for in a photographer. If customers

didn't feel this way why would anyone ever choose a name brand over a generic brand? There are drugs that have the exact same ingredients as the name brand and people still choose the name brand. Why? Perception! Charging prices that are too low gives the appearance that you sell a crap product.

Just in numbers alone the idea of providing a product at such an absurdly low price in comparison to your competition doesn't make sense. Why would you want to do 50 shoots and make just as much as someone that is doing 25? Work smarter, don't give your product away, and do research to determine what you should be charging for your market.

**Discounting**

Another topic that I wasn't planning to discuss is discounting. Discounting is the best way to ensure that you keep your customers paying less. This is especially true if you offer regular discounts. A good example of this is Bed, Bath, and Beyond. Through their direct mail marketing they have been offering 20% off coupons for years. Now whenever a customer wants to buy a product from them they wait until they receive a coupon before purchasing it. Not only have they reduced how much they could be earning per sale from their customer base, they have also ensured that their best customers are only going to show up in the stores when a coupon is available. This is the impact of discounting. Once a customer pays a lower price, they don't want to go back to paying a higher price. This is exactly what happens when you start discounting your photography. You impact how and when your customers buy.

The better option is to instead offer a gift. Instead of doing a $100 discount the customer could pay full price and get a $100 gift card. You could do a photography package that includes a spa day.

There are a lot of different options that are far better than offering a straight $100 discount. By using a gift, you are still offering a reduction in what you are making, but there is a greater perceived value. The customer is now getting something for nothing rather than getting something for something.

It is advisable that if you are going to give away a gift or package that you consider using a company that is an established partner. Not only are you likely to get more for your money by using an established partner, it also reminds the partner that you take the partnership seriously.

If the idea of a gift doesn't appeal to the customer a referral program or a mini shoot may be the better option. Just because a customer is price sensitive doesn't mean that they aren't a buyer at your current pricing structure. Sometimes it means they have to bring a friend so they can take advantage of group pricing OR maybe they just need a smaller, more limited shoot.

The biggest issue with discounting is that it can become the actual price over time. Cheapening the brand only hurts the brand that you have worked hard to build.

www.ingramcontent.com/pod-product-compliance
Lightning Source LLC
Chambersburg PA
CBHW070408190526
45169CB00003B/1166